THE
IMPERFECT
GARDEN

THE IMPERFECT GARDEN

a memoir

by
Adina Sara

photographs by
Rachel Michaelsen

REGENT PRESS
BERKELEY CALIFORNIA

ISBN 13: 978-1-58790-160-7
ISBN 10: 1-58790-160-9
Library of Congress Control Number: 2008940822

PRINTED IN THE U.S.A.
REGENT PRESS
2747 Regent Street
Berkeley, CA 94705
www.regentpress.net

For Nicole, Natalie, and Lucas
that you may one day find gardens
of your own to love

CHAPTERS

TRASH HEAP

Gardening books intimidate me. Those photographs of perfect color-coded, hummingbird-friendly flower beds. Those straight paths and symmetrical shapes. Different blooms for every season.

I knew before I started that no garden of mine would ever look that good. To achieve a book-worthy garden requires stepping back, seeing the space as a whole, each shape, each color decided even before the digging begins.

When I first met my garden, it looked more like a fascinating trash heap. Filled with decades of debris, the garden sprawled through a double-deep lot in a neighborhood once known for apricot and plum orchards. What is now a

garage was once a barn, and the huge expanse of garden area that begins behind the garage and extends 80 feet to the back boundary must have once been a field of fruits, vegetables, animals, and children grown and gone.

The main house on the property dates back to 1903, old for California real estate. The house withstood the San Francisco quake, having been built with real 2x4s, the kind of beams old-timers love to refer to with a smug turn of the lip, declaring, "They don't make 'em like that no more." And they don't. The house has solid knotty-pine walls throughout and closets so big you can bring something to read, curl up inside and stay a while. There's a real attic that only short people (like me) can stand in, and a little hole on the side of the kitchen where milkmen used to deposit glass bottles of fresh milk from days I never knew. Metal lines the drawers below the counter because at one time people bought flour and cornmeal in bulk and actually baked things.

In the mid-1920s, according to county records, another house, called a "granny" unit, was built on the back half of the property,

smack in the middle of the broad expanse of garden. A shack, really, with one small room and a bathroom almost big enough to squat in. That is the house we moved into.

Broken glass shards surrounded the granny unit, all 400 square feet of it, detritus from the years when farms turned fallow and were replaced by freeways and billboards. After the 1940s, houses sprang up everywhere. Plots of lush garden space quickly turned into small lots with little houses requiring big cars that jammed the freeways on three-day weekends, headed for places like this once was. For some lucky reason, this particular parcel escaped the tyranny of subdivision. It was, as Realtors like to boast, a rare find.

I purchased the place with my adventurous then husband. With more brazen confidence than experience, we set out to remodel the granny unit, enlarging the kitchen, adding a bedroom here, another one there, a loft. We ripped through walls, raised ceilings and added windows, windows everywhere. Over the course of our marriage and despite dozens of brushes with city officials, who scratched their

heads but begrudgingly stamped their approval, the little cottage grew to be 1400 square feet huge.

The garden was another story, a tangled tale of brush, broken relics of past gardens, busted glass and brick, reminders of a harsher time. Thorny blackberry vines and indomitable bamboo shoots forced their way up, like giant fists announcing victory. And that was just for starters.

The garbage-strewn landscape was not at all improved by the flotsam of our building adventure. Six years of demolishing and rebuilding resulted in a garden full of discarded 2x4 chunks riddled with nails bent dangerously at odd angles, competing with blankets of blackberry vines that twisted through the wreckage. Vines and weeds fought for their place amid the ruins and often won. As I bent down to extricate tar-stained and treacherous bits of roofing paper, it was the blackberry vines, not the broken bits of glass, that cut my hands.

But I refused to wear gloves. I loved the feel of dirt on skin, the wet, thick blend of

decomposed life. Sometimes my hands would come up bleeding, but other times they would be scented with an exquisite humus of unidentified herb. The more I excavated, the more I enjoyed the connection to the earth, the scents and sensations of being that close.

When I was a child, my parents discouraged me from getting dirty. "Don't play rough" and "Be careful" were the mantras of my childhood, but my parents needn't have bothered with warnings. I was an inside kind of child. Keeping stories of imaginary characters tucked inside the far recesses of my drawers so no one might find them — that was my kind of danger.

Not until I found myself faced with the task of removing sheetrock wedges and roofing nails from the ground did I come to know the feel of dirt on my hands. Grit stuck so deep inside my fingernails that no amount of scrubbing would dissolve it. The dirt became me, and I didn't want to wash it free.

And so it happened that one day, while re-moving a pile of old windows that lay in broken heaps on the ground, I first became acquainted with nasturtium, flattened to a pulp beneath

the wood and broken glass. Once I removed the weighty pieces, the plant stretched awake before my eyes, one round leaf unfurling like an anemone, sunshine-yellow flowers poking out from behind the assault, seemingly un-scathed. What kind of plant, I wondered, manages to bloom despite such abuse?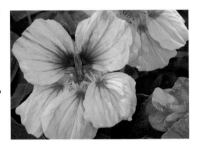

Eventually, the ground was cleared; splintered wood bits, rocks and dust swept away. Underneath, a field of shapes and smells emerged from their lifetimes of mistreatment and neglect. The nasturtium was not alone. Bittersweet feverfew, tiny purple mallow buds and tiny shoots of clover also announced themselves from beneath the rubble, as though they had been waiting for the right time to appear.

These plants were not meant to be tamed but rather to persevere under seemingly impossible conditions.

Those first garden initiates bore no resemblance to the brilliant specimens in

the gardening books, requiring one-quarter teaspoon of this and one-half cup of that to nurture them. These plants bore a strength of purpose and determination that invited my attention.

And so I came to gardening not as a visionary with the intent to tame and make order, but as an explorer, fingers roughened, dirty, and drawn to the excitement of discovery. The garden had something to teach me. I simply had to watch, listen, and learn what it had to say.

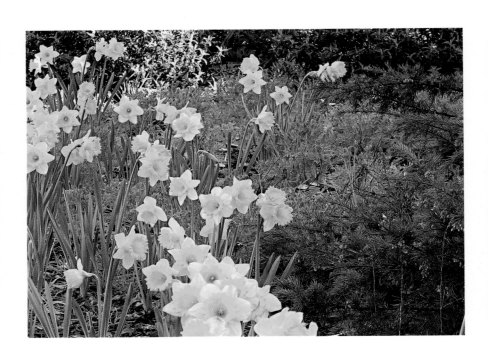

Inside the garden gate
a blanket of green and fleeting
possibilities.
Colors bleed and bake into shades;
soft things affix to stubborn places;
heavy things bend and sigh,
causing obstruction, diversion.

Into this incessant spectacle
I lift a mighty trowel,
to carve a fleeting shape
in destiny

PROPERTY LINES

There was the question of property lines. It was anyone's guess where our property ended and the neighbor's began. Shoddily marked by bed frames and chicken wire, the property lines were not likely to agree with anything the county records could verify. Digging through the rubble that was my garden, I eventually unearthed a museum-worth of rusted metal and tiny glass bottles, crystalline with age. Every inch of landscape bore witness to the tenacity of time. The earth was soft from

neglect, and wherever I set the shovel, I turned up some kind of wonderful thing, a flower bulb or bit of past — a child's doll, a crusted leather coin purse, the jaw of something very small. I didn't know where to start.

I loved poking around in the quiet earth. Small weeds that bloomed, anything green, anything other than the filth and coldness of construction paraphernalia, I considered a thing of beauty. I was getting tired of living in a construction zone, and even though there were still walls to paint and doorknobs to install, I wanted to be outside digging. What lay underneath the soil interested me much more than kitchen cabinets and faucet heads.

Rooting around with the help of a small trowel and sturdy knees, I discovered a dignified-looking weed at the edge of the property. Too nice to be a weed, I thought, though it was completely buried under a pile of broken logs and unfamiliar vines. When I removed the brush around it, the shoot stood up straight, all eight inches of it, feathery leaves growing off the sides as if it might be related to something beautiful.

"What's this?" I asked the neighbor, who

talked as though he knew everything there was to know about gardening. "A weed," he replied. "Better get rid of it. " His side of the questionable property line was not in much better shape than mine — a field of wildness interrupted by a lean-to shack that appeared to pre-date the Department of County Records. He eyed me as I worked, probably concerned I might be trying to wriggle out some extra acreage. Neither of us wanted to pay a surveyor to figure out where his weeds stopped and mine began. It was clear to both of us that this particular weed, standing straight and noble, was well into my side to do with what I wished. Despite his warnings, I couldn't bring myself to pull it. It stood entirely too upright, as though it had a plan, and I wanted to see just what that plan was.

Winter came, what winter there is around here, and I completely forgot about the feathery shoot. It might have been a year later, maybe two, before I ran into this "weed" again. This time I barely recognized it, like a friend's toddler you run into years later, not a toddler anymore, but about your height — and gaining. This

weed was higher than my waist, and the small feathery leaves had grown sleek and formal, something suitable for an entry-hall vase. They were serious leaves. As little as I knew about its origins or intentions, this little weed was looking suspiciously like a tree.

In time my neighbor built a fence to keep my weeds out or his in. Years passed, another fence came and fell, and a new neighbor moved in. Somewhere in between the movements of wind and time, I found myself looking up instead of down, which is how I realized that the fast-growing weed had grown into a thick wall of bark, fully formed and formidable.

Today, the acacia towers way above the rooftop, its giant limbs hovering over the back third of the property, turning everything underneath a shade darker than before. I have been warned more than once, this being earthquake country, that it might behoove me to cut it down rather than have it crash through

the roof, but I could no sooner remove this tree than leave my home. Over the years, its leaves have thickened the ground beneath it into a plush tan carpet. Once in a while I'll notice a tiny sapling peering out from underneath a cracked brick or pile of mulch. I recognize it instantly by the feathery light leaves. Of course I yank every new sprout I see, always gazing up at the great mother tree as if to ask her permission. One acacia, thank you very much, is quite enough.

I marvel not so much at the gaping girth of this tree, though it is humbling to stand dwarfed at its base and realize that I am older. I marvel that I knew, without knowing why, this was a weed worth keeping.

It was no higher than my knee,
a straight wooden line
from soil to lacy head.
It didn't look like anything.

I almost pulled it
but for the faint beginning of shape
like a feather about to open,
tickling my curiosity.

In a forest of distractions
I forgot about this thing
that stood half way between
irksome stick
and beauty.

In the meantime
and without my knowing
this stick grew skyward.
What might have been feathers
exploded into forests
for nests of skittering things, for the
sheer beauty of it.

What stands outside my window now
is connected to the clouds
by a mottled wall so thick
it can be leaned on.
I barely even reach its knotted knee.

I came so close to pulling it
I never would have known
what power passes
between chance and ignorance.

Retreat

We had intended to turn this funky, oversized piece of property into a healing retreat. He had taken up the study of astrology and acupuncture, talking ceaselessly about energies and essences and places people go to in their sleep. Meanwhile, I kept busy planting medicinal herbs, my earthbound contribution to what was to become our little alternative healing center. Drawing graphs and spiraled lines on the backs of paper napkins, we mapped out our magnificent future: he would heal people with needles and trines while I brewed aromatic teas

grown right outside the door.

Medicinal plants are easy to grow. They grow willingly and wildly and offer even a novice gardener the illusion of success. For years I took comfort in artemesia, borage and thyme. I sipped home-grown peppermint tea and soaked in a bath of comfrey root and mallow, blissfully unaware that the plants outside were already beginning to obliterate the landscape.

We had been so busy designing and remodeling our future, we failed to notice that our personal foundation was crumbling. Shortly after the second coat of paint dried, our marriage came apart. I was not smart when it came to relationships. My own root system was already fragile and scarred, having been transplanted a few too many times. This was my second marriage. The first one — the one that promised to last forever — had ended abruptly a decade earlier shortly after producing two beautiful, healthy sons. Shocked by the uproot, we were, none of us, ever the same.

Alone again, I found myself at the dirty end of another crumbled dream. While my heart ached, I woke to discover that the doors of

our magical kingdom were not hung square but tilted just enough to let cold air rush through. So, too, the ill-fitting windows creaked and groaned, almost snickering when I tried to close them.

So I forgot about the herbs, only vaguely aware on damp mornings when the dense musk of mugwort surprised me on my way to the car to rush my boys off to school. Sometimes a bit of lavender brushed my purse on

the way out the gate or settled into their notebooks, its redolent comfort fading by the time

THE IMPERFECT GARDEN

we reached the freeway on-ramp.

Soon enough, my sons were doing their own driving, tending to their teenage selves with the constant hum of friends and cars and activities that raced past my ears too fast to comprehend. I filled the new silences by turning back to the garden, my good old friend, hoping it would forgive me for my callous neglect. I took a closer look at the mass of greenery, relieved to see that nothing had died. In fact, all those medicinal specimens had not only flourished in my absence, but obliterated everything in their path. My garden had turned insolent, out of control, like an unsupervised teenager with boundless and irreverent energy. The borage and comfrey and tansy and rue had turned wild and willful, seeming to mimic the randomness of my life's choices — husbands, jobs, wildflowers, all chosen with little information and forethought.

If I had only read the catalogue, I would have known that it takes but one borage seed to propagate a field thick enough to cover four city blocks. But I was seduced by its furry grey-green leaves, bluebell flowers that flourish for

the better part of two seasons, and self-sowing, to say the least. I was taken in by the billowing shoots of delicious blue flowers not only sweet to the tongue, but healing as well. The bluebells

on the borage and the silhouette of yellow sweet flowers on the mullein had tricked me with all their demulcent promises. The peppermint had a stranglehold on the plum tree, and mature comfrey leaves are anything but comfortable, covered in prickly thorns too small to see. In no time, my medicinal herb garden had me by the crabgrass, and each step forward required an exhausting step back.

In time I learned to spot a newborn mugwort shoot from clear across the garden and yank it clean out. I plucked out the juvenile seedlings

THE IMPERFECT GARDEN

of vervain and tansy before they crowded the walkways. "I know who you are," I'd yell at the feathery tips of baby yarrow, yanking them from between the pavement cracks with a harsh schoolmaster's hand. Even arugula, (how much bitter lettuce can you eat?) had to be seized to allow other winter greens to flourish.

All the while and behind my back, the comfrey continued to grow.

I concede to you, comfrey,
as you spread your sticky roots
gnarled deep past the point where
shovels go,
and push through this landscape
like a railroad through a sleeping
town.

I tried to move you once
You grew back doubled in both places
You grew back hardened and oblivious
You grew back laughing.

Some day I'm going to need you
when my bones begin to break
and nothing else is growing,
having long ago been smothered
by your flightless wings.

It is not a brave feeling
to surrender to a flower,
to know you can be beaten
by a brutish bunch of leaves.

BURIED
TREASURES

Buried beneath the layers of glass and mulch and decomposing past lay hundreds and hundreds of old red bricks. How I wish I knew that story, how they came to be here. Were they tossed from another site? Had this once been the site of a chimney or home of a chimney builder? Did the bricks break apart by the forces of nature or the swift end of an axe?

On any given weed-whacking afternoon, I easily overturned a couple dozen bricks, mostly broken, chipped, most of them scarred with layers of tar and mortar and mud. Some turned up amazingly clean and whole.

I unearthed each one with the enthusiasm of a miner panning gold. Bricks — a strong and versatile building material — became the backbone of this emerging landscape. Bricks created walkways. Bricks formed circles around trees and shrubs. Bricks could be moved, removed and moved again, over and over. Platforms for pottery and statuary emerged out of brick odds and ends. Bricks held together easily with light mortar and came apart just as fast. Rough and rugged, they could still be manipulated at whim. They were consistently imperfect, and so was I.

It's hard to say why I took to brick work so heartily. I hadn't exactly come from a family of masons. The only muscles my ancestors flexed were brain muscles, with little use for physical labor. My father kept to his study during the better part of my childhood and taught me, by example, that physical labor was not for us. My mother handed out checks to a variety of workmen who tended our garden, our roof when it leaked, our porch steps when they broke. She rushed me inside when they came to do their work. "Don't bother them," she

scolded, but I would watch them through the window, their tools and muscles and hardened hands.

I taught myself how to hold a chisel and hammer so as not to gouge any skin from my leg when I chipped the mortar off hundreds of old bricks. I learned the rhythm — steady and slow — the perfect angle for one quick swipe to knock off a thick white chunk in one swoop. I learned how to mix mortar so it didn't drip too fast but still had plenty of give. Bricks

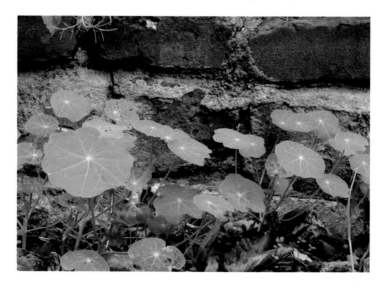

were patient and forgiving teachers. Worst thing I could do, short of smashing my skin, was break yet another brick, and half bricks were

as useful as whole ones. The broken bricks formed the curves and bends and stretched the possibilities.

I am told that used bricks cost more than brand-spanking-new ones. People pay extra for the appearance of history where there is none. There was no shortage of history here. For the mere cost of a sore back and painfully chapped hands, I inherited a gold mine of history. For the first time, maybe ever, I felt a sense of abundance, as though I might be capable of shaping my own destiny.

The mint gets the best of me every time
with its pesky bad manners.
I should treat it like the other weeds,
yanked and tossed wildly into worm-rich bins
that change green into brown and somehow
come back green again.

I grab hard
both hands united
as roots uncover more roots
and arms sting hot and tired
as they tangle with infinity.

Just when I think I see some end
to this commitment, a breeze
sneaks in through the spindling leaves,
sending cold sweet smells up the alleys
of my armor, turning fingertips
to candy — iron will
to languor.

Meanwhile, the mint, coiled in cool sensation,
shakes loose from the insult
of my foolish intentions
returning, undaunted,
to its endless sprawl.

THE WALL

The bamboo was planted back in the 1920s, so the story goes, by neighbors who didn't take kindly to one another. This species of bamboo is not the gentle clumping kind, but rather the kind that sends wild and inconsiderate spikes up and across wide spans of ground. Traversing the entire western boundary line, the bamboo wall measures roughly 80 feet long and 20 feet high. The slightest shift of wind causes its massive wall to bend and creak, littering the landscape with wild debris.

The sound of breezes scratching their way through its thick wall made me think of Hawaii, Tahiti — some place with lots of vowels and

intoxicating drinks. The din of birds nesting high and low within its leaves often overwhelmed the competition of overhead airplanes and car alarms. The birds didn't so much chirp as screech in a stereo boom-box kind of way, creating a madhouse of sound that traveled across the garden and throughout the house.

Reacting to the slightest shift of wind, the limber bamboo stalks swayed across the sunlight, sending a kaleidoscope of shadowy shapes over the ground. In late afternoon, when colors are brightest, the entire landscape appeared to be dancing.

The grand wall came crashing down one day when the next door neighbor's gardener accidentally rammed his rototiller into it and then proceeded to rip to shreds whatever remained. I came home in the afternoon to a tornado of leaves and dust and my dog, whimpering on the doorstep, devastated that her private bone-burial site had been discovered. My sacred garden had been ravaged, its surfaces exposed like a red-hot wound.

The neighbor offered no apology, perhaps thinking she had done me a favor by eradicating

that filthy wall of intractable growth. She had no way of knowing I considered the massive bamboo wall to be the very soul of my landscape. I cried, I screamed bloody epithets, and in the end I needn't have bothered. The bamboo grew back lean and straight in the quick side of a year, as though nothing had happened, nothing at all. It grew back vengeful.

Sometimes I sit in my favorite chair beneath the apple tree (I know it sounds corny, but contentment is like that) and watch for new bamboo shoots. They first appear as pale green tents and soon turn into spears. On a lazy day, I think I can see them stretching before my eyes.

Over time, morning glory and giant New Guinea impatiens have coiled themselves around the base and up through the bamboo wall so it appears to be wearing a white and purple skirt. Stray leaves and flopped-over stalks aside, it is almost lovely.

I continue to monitor the bamboo with vigilance. With patience and acceptance, I continue to pick up the stringy fronds that litter the landscape all year long. I continue to

cut it back and cut it back and cut it back some more.

Never would I recommend planting this variety of bamboo in an urban garden, not for any reason. Nor would I have loved my garden nearly as much had the bamboo not been there.

In a minute
it will slice through
the delicate flat of surface
you call tranquility
and serrate the even edges
of your tidy plans. Even
while you watch, it will cut
in silent places,
leaving unseen ripples in your tender skin.

They say a neighbor planted this wall
some fifty years ago
as a joke
as a threat
as an act of brash audacity
to ward off the foolish sense
we often have
of our own puny power.

The thatched wall is thick
with chirping dialogue,
and in the heavy heat it is good to feel
the cool pale stalks
and think of salty islands.

Even still,
do not turn your back on the bamboo.
Do not take comfort
in the shape of things.

THE GARDENER

With too much space, too little discipline, and the habit of landscaping by trial, error, and surrender, I had created a monster that threatened to destroy my tender-rooted sense of accomplishment. The time had come to hire a gardener.

We were introduced by a mutual friend, who persuaded me that this man had the expertise I needed. Our first impressions were shaky at best. I could barely stand the thick reek of his beer-stained shirt and cigarettes. His country drawl spilled over into endless, winding sentences. From his tall lean frame, he looked down at me with silent scorn, as if to say he knew I was only a city girl, all huffed up with

brazen ideas and not much sense. We weren't the greatest match, but the pathetic, humbling truth was that we needed each other.

I came up with a schedule. He would work every other Wednesday from two to five in the afternoon. It never happened that way. He arrived whenever he felt like it, always an excuse, a broken tool, flat tire, and sometimes he blamed his unpredictability on the weather.

The dark reek of nicotine wafting into my kitchen announced his arrival. Before taking the tools out of his truck, he'd pop open a beer, light up, and turn his radio on. My complaints about punctuality and agreements were drowned out by his maddening country music station.

But when I watched him out there turning soil, straightening rows, adding bone-, then blood meal, my frustration dissolved. He spent hours sprawled under the cracked, fallen plum tree, resurrecting it from what might have been disaster. I watched him move through the shapes of the foliage. How he set himself down lightly on the ground, studying the surface for errant weeds, flaws. How he guided the final pull of rake, snipped a finished twig.

At pruning time I'd stand behind him, see how closely he studied the angles and lines. Under his direction, I'd snip off a twig, two nubs in, remembering his admonition that no cut is unintentional, no line unimportant.

Sometimes we'd just hang out and talk. I can't say about what. It was a slow-drip kind of talk, sharing our different backgrounds and lives until the differences faded. He taught me that the spindly groundcover I was trying to eradicate was a delicious food called purslane. "Full of Vitamin C. Just steam it a little. "

Another weed I almost pulled, salsify, sprouted a startling blue ball. He told me stories about salsify, a shapeless weed he recognized from his boyhood days in Eastern Pennsylvania, how his mom cooked it just right with a little butter.

I would listen to him, hands curled around my knees like a child intent on a favorite story. He had things to say about tree roots, about the lines of rock. I unhooked my sense of time, removed my preconceptions, and at last began to listen.

The cigarettes and booze finally caught up

with him. As he grew weak and unable to work, he insisted it was just a cold that wouldn't go away. But he knew and I knew. We just didn't say. Nature protected him from himself, at least for a while.

I stumbled along without him. I bought new soaker hoses and a special nozzle he insisted I use for the roses. There is nothing in my garden that lacks his signature, the grapevine woven through the deck slats, the shaping of stones. It feels like everything I know about gardening can be traced directly to something he said or did or warned me about. I move the heuchera into a shadier spot (I can almost hear his "I told you so"), sprinkle nitrogen and bonemeal here and there, just as he taught me, and remember to fill the birdfeeder. I pull a leaf of purslane, sweet on my tongue, and think how easily I could have missed all of this.

I watch him lift bulging bags
of sautéed brine, stinking with life,
decayed to order. He builds the layers
prudently, equal parts foulness and fluff,
that conjure unattended poolrooms,
fissures in ocean walls.

With a mother's aching arms
he tends and turns,
breathing in the dankness,
feeling in this formlessness
the possibility of life.

 I set my sights on luscious flavors
 fragrant colors NOW
 Rushing sunburned plants into
 brown and dusty dirt
 expecting a reward,
 while he

Simmers the invertebrate stew
slowly,
knowing
the tip of life balances
on what worms do.

TINY BLACK DOTS

I am a sucker for seed packets. How can anyone resist a profusion of flowers covering 250 square feet for less than three dollars? Instructions are so simple: "Sow seeds after all danger of frost is past. " I gather up handfuls of seed packets, splay them like a bouquet, and realize there is no need to choose. I can buy them all and still get change from a twenty.

When my sons were little, I'd give them seed packets, hoping they'd follow my lead. "Come on," I'd say in my best-spirited voice, "come help Mommy plant some lettuce. " I imagined us picking carrots together, imagined their bright-eyed surprise to see radishes emerge

from those tiny black dots. But if they heard my call to plant, they didn't let on. They were too busy slamming basketballs against the garage wall or trampling through flower beds to make miraculous left-handed saves. I'd find the torn, dried-up seed packets I had given them inside the winter-wet bins where the balls and bats were stored, sadly twisted sprouts reaching out to nothing.

I continued undaunted in my passion for tossing seeds around. I carefully split the corners of the packet and spilled dime-size clusters of miniscule black dots into the sweaty creases of my skin.

Over the years I must have sprinkled thousands of tiny dots into the ground in evenly spaced rows, one quarter inch deep, followed by a fine dust of dirt. I even labeled them with name and date, though the labels faded or fell away. I did everything exactly as the packet said and went on my way.

Seed planting is for responsible and diligent gardeners, not the lazy or distracted. Even easy-to-grow and hardy seed varieties like cosmos and zinnias require constant watering,

inspecting, protecting, thinning, and more watering. Planting several packets of the same variety may raise the odds of a lavish display, but all sorts of obstacles pop up in the Seed-to-Flower story. A hose dragged along the dirt, the neighbor's cat, not to mention a week's vacation, can instantly upset your perfect seed plan. Seeds get caught and carried in the grooves of shoes. And of course the birds have plans of their own.

That's not even mentioning the snails, who patiently lie in wait for the little green shoots, should they ever manage to finally present themselves.

My neighbor gives me seeds she collects from her last year's crop, carefully gathering the little dots into well-marked baggies, once they've been carefully dried so as not to mold or sprout doomed growth inside the plastic bag. She color-codes her labels on small wooden sticks (the kind doctors use to poke open sore throats), indicating year, color, and variety. She's a real gardener. She knows that plants have histories. I receive her packets of Aquilegia chrysantha, and Helichrysum

bracteatum (why doesn't she just *say* columbine and strawflowers?), all carefully marked by year and description (loves shade, pale yellow/coral stripes). She always assures me that last year's production was magnificent, and there's no reason they won't perform again.

I scatter them carefully, covering them with a fine silt of dirt, almost blessing them with consideration. I mark them with little wooden sticks. Time goes by, and I forget. Soon enough, the random sprouts appear, reminding me. Unidentifiable and formless, they open up to the light everywhere but in the perfect spot I had seriously intended they go.

It wouldn't be so bad if they didn't come up at all. But the seeds play tricks — marigolds between the patio bricks, cilantro by the woodpile, nowhere near the lettuce bed where they were supposed to be. And how on earth did the clarkia survive the exhaust fumes in the driveway, and why didn't they flourish in the carefully prepared cut-flower bed where they were originally tossed?

Still I try. Real gardeners grow from seed. Haven't I been doing this long enough to qualify?

Every year I buy more seed packets and happily accept my neighbor's generous offerings. Free flowers, pennies to the bloom. I think I'll put them right over here.

One day, I am certain, it will all come around. With enough tromping through flower beds, enough birds flitting this way and that, the proper order should eventually find itself. Last year a volunteer tomato did come up, miraculously, smack inside the vegetable bed. The hollyhock seeds, originally intended for a hot corridor, landed in a sunless corner that bred mildewy pale blooms. But two seasons later they managed to reappear in the exact

spot they were originally sown, neon-bright blooms, eight feet tall and climbing. Maybe they had gone dormant in the grooves of my garden shoes all that time. Or maybe it was the birds. Who knows?

The mixed and matched violas
I carefully selected
withered and died.

Just as

a stray circle of calendulas
came up in perfect symmetry
around the lemon tree.

THE NAMES
OF PLANTS

I'm not good with the names of plants. I say *coreopsis* when I mean ceanothus, and though I have erigeron, (also known as aspen daisies) sprawling along my walkway, the name keeps slipping off my tongue. I switch hosta with heuchera, and confuse the lovely corn lily, ixia, with ibis (a large wading bird).

I didn't consider this a problem until my neighbors saw me walking around wearing a gardener's belt, trowels and sprinkler heads clacking against my thighs like six-shooters, and started asking me gardening questions. "What's the matter with my lamb's ears?" "How come your sage is blooming and mine isn't?" When

guesses no longer worked, I decided it was time to take a gardening class. Plant Identification I, offered at the local community college, seemed as good a place as any to start.

I considered myself way beyond beginner. I had scars on my hands to prove it. But waiting for the class to start, I overheard other students comparing white fly remedies, debating eisinia vs. red worms in their compost bins, gloating over a successful lime tree graft. I shrunk down in my seat and kept my mouth shut. After all these years of digging and planting and digging some more, it was clear I was still a rank beginner.

But bit by bit, the mystery of plant terminology unraveled. Latin names became less daunting once I learned that *chinensis, canadinensis,* and *virginiensis,* merely described the plant's geographical origin. And suffixes told stories. Repens referred to creeping varieties, *scabiosa* meant the leaves were rough, and *fructosa* indicated a plant was shrubby. Words like *grandiflora* and *spectabilis* pretty much defined themselves, and *schizophyllia* (split leaf) and *triphyllus* (three leaves) were relatively

easy to decipher. Feeling less overwhelmed by the time *juniperus occidentalis* crossed my path, I grew smug with confidence. Right up until the final exam.

The teacher laid bunches of unremarkable leaves and twigs across the table, marked by numbers, and asked that we identify them by correctly spelled Latin names along with flower and growth descriptors. I got as far as *Cerastium tomentosum* and *Heterocentron elegans,* when my brain froze. As I played for time, picking at a mud clod lodged beneath my fingernail (a remnant from yesterday's bout with crabgrass), I was jolted by an epiphany. I didn't need to know *Helianthus compositae* and *Rubiacaea jasminoides* when sunflower and gardenia suited me just fine.

And so ended my botanical academic career. The Latin names stayed in my brain about as long as a cut poppy lasts in water. In a few weeks I was back to "the pink one with the little drooping ends," though in my sleep, the name *Dicentris spectabilis* still rears its impressive head when I have absolutely no use for it.

Because I couldn't remember *ceanothus,* I

ended up with *Solanum jasminoides,* the prolific shrub along my back fence that produces a generous supply of blue flowers throughout most of the year. The nurseryman patiently tapped his foot when I asked "Do you have any...?" unable to remember what I came for.

"What does it look like?" he asked, and then introduced me to a host of hardy, blue-flowering perennials — *plumbago, campanula, anise hyssop* — but it was the *Solanum jasminoides* that caught my eye, towering over them all with lush determination.

In the same way, I ended up with the *Melianthus major,* a magnificent giant of a plant with spiked red flowers. Every spring it attracts a brilliant yellow goldfinch and throughout the year provides a dramatic backdrop of zigzagged gray-green leaves. I had gone to the nursery specifically looking for ... well, I can't remember the name. It started with "m".

A new neighbor showed me a notebook that her home's previous owner left for her. It was filled with the Latin and common name of every plant in the garden, along with date of planting, soil requirements, etc. I wish someone would

do that for my garden. The little identification tags I stick in the soil invariably get washed away, and I'm not sure if the bush with the delicate yellow blooms is evening primrose or coreopsis. It looks like evening primrose though the tag says coreopsis, but I think *that* plant died last winter.

I call it the lemon bush, and it doesn't seem to mind a bit.

Uninvited Guests

I still can't say how they all landed where they did, much less where they came from — the mismatched shrubs and bulbs and unnamed perennials that dot this landscape. Despite the utter thrill of emptying my car of flats and flats of brand-new nursery purchases, when I surveyed my emerging landscape, it seemed as if most of the plant materials that succeeded and thrived had come to me by way of mystery.

The bulbs, for instance. Everywhere I turn, thick clumps of fresh young shoots promise

to do something spectacular. I can't recall purchasing a single bulb. But tiny blue ipheion shoots have gnarled their way out from between the stepping stones, having tripled in girth from last year. Freesia tips are peeking out from a thick carpet of clover, and steadfast daffodils stand tall in a bed of wet leaves, along with what looks to be hyacinth.

I know a gardener who plants only tulips. For three weeks every year her garden explodes in orgiastic giddiness, then lies fallow for the next 49 weeks. For her, it's tulips or nothing. Another gardener I know has two passions: daffodils and dahlias. Every November she says goodbye to one and plants the other. Come April, vice versa. It's a clean, ordered kind of life, knowing that for several months of the year, passing cars will slow to a stop to admire a breathtaking display of abundance. And the rest of the time, plain old dirt.

I scatter bulbs aimlessly, changing opinions from season to season as to the best spot. As I move them from one bed to another, invariably a few fall loose in transit. Those are the ones that dig themselves in the deepest. I prefer the

randomness, the way one stray daffodil stands sad amid a circle of freesias, and then a thick bunch of them gather together with their bright yellow eyes and white ruffled hats, like ladies whispering secrets in the sunlight.

A strange species of mallow once appeared in the dead center of the rose bed. I trained it to become a sort of tree, clipping the bottom branches, and enjoying its purple blooms. But we both knew it wasn't a tree. It's a biennial that thinks it's a tree, and why should I pull it? In two years it will die anyway from its own limited will. Reasonable gardeners would have pulled it the minute they recognized it, but I am fascinated by plants that rise up of their own accord. Like uninvited guests, they deserve at least a brief acknowledgment, and who knows, they may turn out to be more interesting than the invited ones.

It continues like this, year after year. Plants die and come again, some stay buried for years

and then reemerge, stronger, it seems, and all the more appreciated. I kneel down between the rows, cut away perfectly acceptable impatiens blooms, in order to expose the alstroemeria choking for attention. One day I was clearing out dead leaves and there it was, the dahlia bed I had planted a ways back and forgotten about. At the time, it seemed like a good spot to plant dahlias, but the apple tree and bamboo had overtaken the corner, and the dahlias didn't get nearly the light they needed to bloom. There they were, buried under heaps of bulb and bamboo droppings, still sprouting green leaves out of sheer stubbornness. All those years of potential blooms had gone to waste, but no sense dwelling on that now.

I dug the dahlias up, found a proper sunny spot where something else had come and gone, and within weeks they had doubled in height and girth. It appears they have forgiven me.

And over there, the boring but bountiful marguerites have obliterated a sweet, soft-spreading shrub — orange clawlike flowers sprawled over a soft bed of feathery leaves, one of those spontaneous nursery purchases,

sadly dwarfed but still alive. Meanwhile, the penstemon are everywhere, flopping loose and out of control. I forgive them because they bloom unconditionally.

I couldn't possibly have planned the iris bed. The irises looked as if they had been there forever, their bases thick and gnarled like tropical jungle specimens. I pretty much left them alone, so I didn't notice when an errant flock of borage seeds nestled between them. Subtle at first, but soon enough a brilliant waterfall of bluebell flowers opened amid the white and yellow iris blooms. It was a Monet moment that lasted for several weeks. I will never be able to replicate it, not quite like that.

And that is how it is. I make intelligent decisions for or against the usefulness of a particular plant, for or against a color scheme or leaf pattern. And then I change my mind. Or the weather changes. Or a branch breaks. Or I see something at the nursery that is insanely gorgeous and I'll find a place for it, somewhere. And plants have their own intelligence. Whenever I begin to consider myself somewhat of an expert, interspersing hyssop with honeysuckle,

balancing love-lies-bleeding with deep blue del-
phinium (the bamboo eventually buried them
both), a perfectly unsuitable mallow will sprout
inside the rose bed, and I do nothing to stop
it.

The visitors wear forgiving smiles, they say
 your garden is so wild
as if these leafy paths
and flopping blooms
were not themselves a finished thing.

And what if all these stooping years
have come to this:
Drifts of nierembergia along the jagged
paths;
an anagram of landscape
sown by scattered hands.

 Watch your step!
 You can eat the purple things
 help yourself, they are everywhere.

And thank you just the same
for all those delicate suggestions.
I will plant them one-quarter inch deep
in well-drained soil
and watch them grow
savage in the sun.

UPHEAVAL

Completing the turn onto my street one Sunday afternoon in March, I was shocked by a haze of activity — fire engines, neighbors gathered outside, and long water snakes slithering the length of the street, up a long driveway, my driveway, leading to the back house, my house, my home.

I walked up my driveway as firefighters approached me with clipboards, asking brisk, efficient questions. Notes were taken. Opinions as vaporous as the blackened air were tossed around.

Someone guided me into the blackness that had been my home. Plants hung from the walls like dead bats in a cave. The smell of water and ash and hot mist was everywhere.

THE IMPERFECT GARDEN

What followed was a blur of days and decisions. My insurance agent arrived at the doorstep the next day (State Farm *was* there) and handed me a check, told me to buy some clothes for my sons. Unidentified neighbors left food on the darkened doorstep; friends gave me shelter. I was too shocked to thank them.

My sons and I moved to the comfort of a modern apartment complex located on luxurious landfill. Complete with swimming pool, sauna, weight room and cable hook-ups, it was a teenager's paradise, virtually maintenance-free. My sons and their buddies streamed in and out of the complex like flocks of low-flying birds, leaving quick answers — "We'll be home later, Mom, don't worry" — and mountainous heaps of sweaty clothes in their wake.

Though I wouldn't have admitted it possible back when I was digging up bricks and tearing up my hands with blackberry vines, I adjusted easily to the built-in kitchen, the unspoiled countertops, the kind of order that makes a point of itself. A few weeks earlier I had been scraping uneaten food from the dinner plates into the compost bucket. Now, I carried plastic

garbage bags across the hallway and deposited them into an antiseptic trash chute that snapped shut with plastic precision.

But soon after the calm of apartment living settled in, I turned my attention to the task of rebuilding my material world, fork by chair by hairbrush. Every day was a frenzy of activity. I needed sheets, knives, sponges, frying pans, toothpaste, tables, socks. I needed to meet with the contractor back at my house to make decisions about tiles and ceiling fixtures. There were paint samples to consider and papers to sign. I shuffled between burned house and sparse apartment, sent my sons flying through malls with newly minted credit cards to replace t-shirts, golf clubs, Levi's 501s, all the essentials. I spent hours choosing blouses, shoes, earrings, dressing myself from the skin out to replace every single solitary item in my bedroom that had gone up in smoke. It was a time to deal with the new, forget about the old, and not think too much about what lay ahead.

I didn't dare visit my garden. Not right away. When you need shoes and underwear, you can't think about how the bougainvillea is doing.

I did, eventually, go back to my fire-ravaged home to survey the horrific damage. Though the construction workers were respectful, the blackened rafters had to be tossed somewhere. And where were they supposed to stack 2x4s and roofing paper and sheets of plywood and sheetrock and nails? The garden, once again, became a trash heap.

I didn't expect to see anything blooming, certainly not the delicate princess flower blossoms, certainly not the hyacinth. But the breezes must have been blowing inward that day. Only the old pittosporum, planted out back long before I moved here, showed traces of trauma. Otherwise, all the plants survived unscathed. The apple tree blared its blossoms, foretelling a bumper crop come summer, and the ever-blooming impatiens hadn't so much as winced in the heat.

I tiptoed over the plywood stacks, careful not to twist an ankle in the rubble. I attempted to pick up dead leaves, flick away sheetrock dust that had settled on the honeysuckle, leaned in close to smell the freesias. I couldn't see them through my tears.

HOME AGAIN

The reconstruction of my home was moving ahead according to schedule. As I carefully stepped between carpenters, painters, and building inspectors to survey the progress, I was struck with the unfamiliarity of my once familiar surroundings. The smell of just-installed carpets reminded me of the waiting room in my dentist's office. The pencil marks indicating growth spurts on my sons' bedroom doorframe had been painted over with a nondescript shade of neutral. No traces of scuff marks behind where their beds had been. No basketball dents in the walls. The shade of salmon I had chosen for the kitchen

countertops from a little sample book turned out to be Economy Motel Orange.

My friends all asked if I was excited to move back home, but this place bore no resemblance. My youngest son, now graduated from high school, was packing up his things, eager to leave the apartment complex for his new life in an out-of-town college. There was no past to return to, I couldn't see into the future, and the present was weighed down with store boxes and Bubble Wrap.

But one evening I attended a party of a friend of a friend. First impressions are strong, and we still recall, in humorous detail, that first moment across a crowded room, strangers, like in the song, only I was standing in line waiting for a bathroom to free up and he cornered me with his marble-green eyes. We each thought the other entirely too attractive to be interested.

He lived in the country, or so I called it, a fairly built-up community fifty miles north of the bustling Bay Area. Streets had no sidewalks, and a faint smell of cow manure and sweet grass perfumed the narrow road that led to his cottage. After months of going back and forth

between his rural retreat and my temporary apartment, I decided it was time to change scenery altogether. I found eager tenants to cover the mortgage while I set off on a new adventure.

For three years we rented a farmhouse at the far end of a pavement-free country road on a ten-acre apple orchard about five miles from town. The community was a congenial mix of old-timer farmers and ecologically correct alternative types. Downtown offered a quaint two-block-long medley of crystal shops, third-world import boutiques, and health food stores galore. The sidewalks oozed with patchouli oil and hypnotic music. Lovely though not helpful when you needed to buy toilet paper or deodorant.

But I never stopped feeling like a tourist for the three years we lived there. I tried, really tried, to see if I could uproot my big-city sensibilities and make a home in the country. I made awkward attempts at vegetable gardening amid the apple and peach orchards that overwhelmed the landscape. The fields turned yellow with wild mustard in the winter time,

and in the spring, the farmland weeds were much too much for me to tackle. Potted plants on the front porch were all I could manage. I sat on a rickety wooden chair on the rickety front porch and looked wistfully out at the orchards, missing my garden, the place I called home.

We married in the country but agreed to move back to my city home, where my long-lost garden eagerly waited. The tenants had been respectful stewards, leaving behind a few succulents and a bougainvillea, along with warming scents of curry and nutmeg that permeated the walls, welcoming us home. We settled in, his old furniture bumping into my

new furniture as we edged our two lives into familiar and unfamiliar spaces. This was nothing like the place I had built with my ex. That place, with its bent nails and crooked countertops, was now completely transformed. Only the smell of honeysuckle wafting through the kitchen door reminded me.

My new sweet love of a husband was no gardener. He associated gardening with the shrill voice of his mother admonishing his father for not cutting the grass on hot humid East Coast summer afternoons, when all the man wanted was to pitch balls to his waiting son. When I said, "Come on, let's work in the garden," no matter how lilting my voice, he heard the tyrannical sound of an angry wife demanding sweat at the most inopportune time.

He would go out, begrudgingly, after preparing himself as if for minor battle. Knee pads, water bottles, sunscreen, heavy gloves. You'd think I was asking him to dynamite a small mountain when all I really wanted was to kneel beside him in the dirt.

Little by little the space called to him, albeit

in a different language. He was drawn to the power tools — leaf blowers and edgers. He found his own ways of communing. I'd see him up on the roof, clearing out gutters, or high on a ladder, clipping morning glory away from the electrical wires. He busied himself with tasks I'd never dream of doing. He found peace in the practical, preventive aspects of gardening — cutting back the old rose so it didn't threaten to scratch people's eyes out when they walked through the gate; clearing walkways so one could actually get through. Meanwhile, I continued to busy myself adding, adding, adding new things to play with.

And after his work was over, while I continued to pull and yank and haul, he quietly carried out trays of sandwiches, salads and glasses of wine onto the deck, where he beckoned me to come, sit down, eat, watch the moon, listen to crickets, smell the jasmine, the rose, the night.

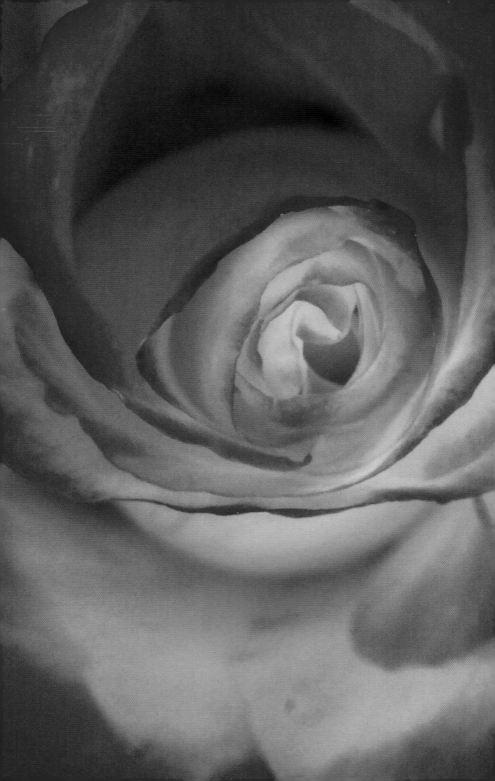

I named it Mystery Rose
having brought it home without a bud;
It could have been another nameless pink
or faint yellow like its neighbor.

It took its sweet time to open.
It was so swollen, disfigured,
I thought it would burst.

But it opened
like any mystery,
one layer at a time:
First dark as thorn-drawn blood,
then the tawny middle child, blushing,
like perfume on a waiting cheek.

At last, when this unfolding ceased,
and I began to think I knew just what it
was,
one last layer announced itself
in whorls of skirted white,
daring me to speak the name
of mystery.

LETTING GO

We received a hoya plant as a wedding gift. The rare Hawaiian cultivar promised exquisite, aromatic yellow flowers "when the time is right." Like marriage, we were told, it would improve with age. I set the hoya in a recommended sunny spot, and for a few months waxy green leaves sprouted at the tips, showing promise. When the leaves started turning brown I moved the plant to a shadier spot where it sat for several years, still green but without a hint of bloom. I decided to train it up the deck posts (it is a vine after all) outside the bedroom window, where it could vie for attention from both sun and shade. I imagined

being surprised by its professed fragrance some wonderful morning. By all accounts, the hoya flower was a bloom worth waiting for.

Our third anniversary came and went, the fifth, seventh, ninth. Over the years, the hoya had grown thick with heavy waxed leaves, unable to wrap or cling as vines are supposed to. I stapled the branches up along the wood posts, hoping to guide them toward the light. But instead of climbing, the hoya stooped. By now, my pride was involved, along with a superstitious concern for a wedding gift that refused to bloom.

I pored through pages on hoyas, took impressive notes, changed soil, fertilized, watered more and then less, but the situation did not improve. On the contrary, the plant developed a nasty infestation of yellow bugs that enjoyed feasting on the fresh new tips. I sprayed it with an organic mixture of olive oil, castile soap and water, tried removing the crawling yellow dots with a soft cloth, and finally, out of desperation, hit it with some toxic stuff. Still, the yellow bugs survived.

The time had come to give up on the hoya. Since I couldn't bring myself to toss it into the

compost, I opted for a more passive-aggressive approach. I carefully removed the staples that held its massive bug-infested limbs to the deck posts, cut it back considerably, and set it way out in the corner where only the jades and cactus grow. "You're on your own now," I scolded. "You either will or you won't. " Marriage symbol or no marriage symbol, I had more important things to do.

A hard lesson in gardening: sometimes you just have to know when to nurture and when to let go.

I had an even harder time letting go of the Melianthus major. Back when it was in a four-inch pot, the unusual zigzagged leaves had tricked me with their promise of whimsy. I was also impressed with its common name, honey bush, so sweetly appealing. Turns out the honey bush adored my soil conditions, as its tall, clawlike limbs sprawled quickly over the freesia bed and into the walkway. It appeared to be planning a takeover of the deck. So I decided to remove it altogether — dig it down to its core. This turned into a four-handed operation. As my husband dug, I extricated

roots. He yanked, I pushed, our sweat irrigating the hole as the little job evolved into a back-breaking task. Exhausted, we grabbed hold of the monster root with all the strength we had left and wrestled it free. It took the two of us to lift it at the count of three, and it completely filled the 32-gallon garden waste bin. We spent the rest of the afternoon slumped in garden chairs, exhausted and ecstatic that at long last the Melianthus was gone.

Wrong. The shoots came back. Under the chair, under the freesias, under the brick path. I recognized them right away, knew them to be the cute little offspring of that monster perennial. My new task, which would continue for years to come, would be the hunting down and plucking out of honey bush shoots so they'd never see the light of day. One more thing to add to the bamboo, comfrey, and blackberry list.

And then there's the oxalis. Despite all the bad press, there is much to be said for the invasive little weed. When everything is either dead, overgrown, or uninspired, the bright yellow flowers of oxalis can always be counted on to fill in the gaps. And weeding feels gentle

and easy. One short tug on the soft green stems and a hefty fist of flowers comes loose. With a handful of groceries in one arm, a kicking child in the other, you can still manage to snag a whole row of oxalis without getting so much as a clod of dirt on your hands.

Eradication is another story. For years I attempted to extricate oxalis by its roots, but the roots are a mass of white worms wedged deep beneath the soggy soil, wriggling their stubborn way in every direction. Even after an earnest afternoon of filling buckets and more buckets with oxalis sprouts, I'd notice how quickly they returned to beat me at the game. Still I hunker down, grabbing fistfuls of oxalis bulbs, mud and all, my fingers like knives cutting away at unwanted flesh. There are days when I am in exactly the kind of mood it takes to attack oxalis, days when I actually enjoy the lush foolishness of futility.

So much of gardening is destruction, eradication, saying no. Brown limbs have to be cut away, dead leaves removed. Even young, eager shoots must be severed. Perfectly good fruit must be plucked off before ripening in

order to allow other fruit to peak. Death in the garden is rampant, celebratory, a pathway to the future. The task of gardening requires an equal penchant for destruction and creation, one following the other so closely they often appear to be the same.

Some of them are not so bad
oxalis, for instance,
offering up the innocence of yellow
on such tentative stems.

And the creeping clogging violets,
they will grip you by the wrist,
they will not go gently,
and tiny threads of purple offer solace
after all.

Calendulas,
nasturtium
stomping out subtlety
in fits of tumbling orange,
aren't they just another name for weed?

There is no poem for the crabgrass.
no kind way to untangle the thicket,
not with words, not with metal-jagged tools
designed to tame the tainted landscape.

Dandelion, mallow, thistle
it's the same old story,
uninvited guests, plans for perfection,
the endless desire for order
pitted against the nature of things.

PRUNING BY PUPPY

My old dog finally died, her ashes now scattered beneath the acacia tree and under the porch, where she had fashioned a lair from fallen grape leaves.

My new pup may well have been a gardener in a past life, seeing how she derived such pleasure from pruning branches, digging deep holes, and transferring dirt from one place to another. She planted anything she could hold in her mouth — bones, slippers, expensive dog toys, and she even knew to cover them three inches deep. In a few short months, the night-blooming jasmine that I had spent years training to cascade over the front porch was reduced to a stubbly mass

of twigs. She mangled the Dusty Miller beyond recognition, and I don't even want to talk about what she did to the tricolor abutilon that had finally rounded the corner fence.

And so my gardening tasks were reduced to filling in the holes she dug, sweeping up dirt she excavated from the pots on the deck, making the rounds with the pooper scooper. I tried a dog-repellant spray, but it only repelled me. I stopped planting altogether, all garden hours taken up thoroughly with damage-control activities. Time and money were spent to cordon off a separate doggie section, but it was like closing the barn door. The vegetable beds would have to lie fallow until she was safely secured, and the whole place was beginning to look more like a kennel, less like a place of beauty. For some lucky reason, the puppy had failed to discover the honeysuckle, and for this I was grateful. All the hard-working prior years were instantly blurred into a single bland fact: my garden had gone to the dog.

But if not a dog, it could have been anything. Decades of fine tuning, pruning, improving, can be undone in no time at all. A stranger three

blocks away may decide to cut the oak that had been blocking your view of a god-awful billboard. A collapsed perimeter vine can expose you to early-morning schoolyard noises or the back-fence neighbor's rusted car collection. In the flash of a chain saw, gardens die and reemerge. Despite all the plans, the exciting trips to the nursery, the waiting and reaping, without notice or sympathy, gardens remind us that we are only slightly in control.

Sure enough, a growing season later, my puppy, now a full-fledged dog, matured right along with the plants I thought she had destroyed. Nothing like a little bit of time to heal garden catastrophes. Though I really thought the zauschneria, jasmine, and two potted fuchsias were goners, they managed to survive being used as chew toys. In fact, more than survive, they had grown back to full size with an unequalled fervor and brilliance. The

THE IMPERFECT GARDEN

green of the jasmine had deepened, giving off a waxy glow, as though the abuse it had suffered encouraged it to rebound with new determination. Both potted fuchsias grew substantially larger than last year, and I swear the blooms were bigger too. Turns out that Decimation by Dog was just what the plants needed. So much for tender little snips here and there; so much for gentle dead-heading. The plants had been gnawed down to the chlorophyll, and still they came back thriving.

Mercifully, my dog has outgrown her desire to mangle plants. She prefers to curl up on her dog bed, occasionally snapping at flies, real and imaginary. I have returned to the pleasures of gardening, though my dog's brief foray into pruning helped silence the "Am I doing this right?" mantra that used to accompany my every snip. I know now that anyone can prune. Despite what may appear to be a catastrophe when an overgrown shrub is cut down to size, that may be the best way to rejuvenate it.

If only all mistakes were so easily forgiven.

Underneath six years of bulb leaves,
packed down like woven blankets
where stray seedlings
often start themselves
and then are too forgotten,

The old horehound unfurled itself
along the cobbled path
looking quite like itself,
looking even proud.
Like Rip Van Winkle roused,
it stood up tall, unshaken
as though it always was.

What was it doing all that time?
Did it sleep silently through the seasons?
Or did it billow and bloom
for its own sake?

You wouldn't know it now
with its cool gray fur
draped so deftly over a
necklace of stones
that glistens in the new light,
not even a leaf
out of place.

HARVEST

My husband takes the basket, fills it with tomatoes (some still green), two small peppers, and one deformed crookneck squash, its broken neck bent at two angles, as if reset by a near-sighted surgeon. Also, a fistful of green beans, barely enough for a meal, but we'll steam them and chop them into the salad, along with a single radish (the others, not thinned enough, now gnarled red pencil-like tips). He brings the bounty inside, spreads it across the kitchen counter, leaving one oversized winter squash on the porch. Only a machete can split it into pieces suitable for baking, though it will likely

remain out there until it rots, a testament to our erratic relationship to vegetable gardening.

The odd eccentric shapes and sizes of our garden vegetables practically announce themselves as home-grown, only barely resembling the perfectly orbed and uniform displays in supermarket bins. Our garden may not produce perfect vegetables, but they are *our* vegetables. We take slow sumptuous bites, declaring to ourselves — our private audience of two — "mmmmmmm," as though the delight in eating food from our soil requires announcement.

Back in the days when the garden was a construction zone, I managed to get a couple of carrots out of the mayhem, even grew a row of celery (ropelike and stringy) in between the sheetrock debris. Though the results were paltry, the effort itself felt like a valiant achievement, creating life out of chaos. It is a good thing I've never had to actually survive on the food I've planted. Still, the thrill of growing my own food feels a bit like prayer, fervent yet quiet, bringing me back to an ancient source of comfort.

Despite all careful designs, the vegetables

seem to ripen when they ripen — some weeks all at once, and then weeks of green, hard fruit waiting for the fog to clear. The tomato varieties that promised to be large ended up looking like oversized cherries, and a medium variety produced tomatoes the size of grapefruit. I have given up trying to predict vegetable production, and what does it matter anyway? Every day we fill baskets with peppers, tomatoes, basil, squash, sprays of thyme, and chives tossed in for good measure.

In the dark, I go outside with a flashlight, grab enough greens for a salad, snag a few slips of chives and marjoram from a pot next to the back door, and pretend that I live in another time. Wiping my hands on an imaginary apron, I imagine the smell of bread baking, the steady rhythms of life. I was born and raised in a huge metropolitan city, and none of this vegetable-growing business comes naturally. If it weren't for my husband, this trancelike insistence on having a vegetable garden would end at its beginning. My husband is the one who remembers to go outside and actually harvest when the food begins to form. Once I've passed

beyond the holy motions of planting, I go on my way, content that the growing and dissolving will proceed without my intervention. Lucky for me I have a mate who remembers to check on the progress, discovering the first baby peas, the tomato not quite red yet but just about ready. Later in the season he will poke beneath the fallen clumps of old growth to wrestle out one last squash, a couple of sorry green tomatoes, a pea pod so huge the tenderness has all but gone.

Like all marriages, ours has its difficulties. It seems that every union has places where the two people collide. Marriage is work, a humbling cliché, but when I think about our vegetable garden, how I plan and plant while he tends and harvests, I know our union is complete. Despite the crooked fat squashes and two-pronged tomatoes and arugula that overtakes the quaint and delicate heirloom greens, bounty, whatever the form and shape and taste, is bounty nonetheless.

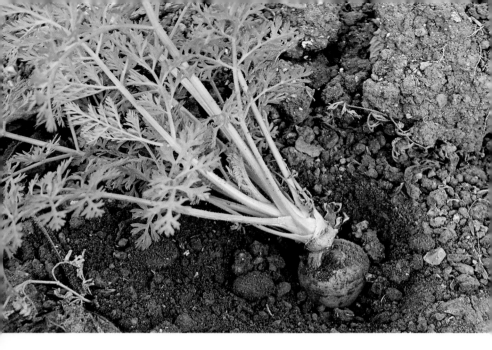

How To Grow A Carrot

I

Open up your palm and touch
the light white flakes
Careful
A breeze could send them soaring
They could vanish in the sun

II

Cast the flakes in even rows
one-quarter inch beneath
the shifts of winds
Cover, not smother in blankets
of warm night
in weightless earth hairs, shelter them

III

Dampen like first kisses
To soften, not enter
Let the dewy drippings tempt
their waiting roots

IV

There will be pale green fronds
no thicker than eyelash,
and this is a good sign

V

You will go about the business
of summer
You will leave town
You will write and toss the clippings
of unpleasing words
You will forget
you ever planted anything

VI

Some time next winter
the shovel turns up convoluted fibers
of gnomelike proportion
and the sweet smell of mud
and orange lingers
like all neglected intentions

MUSEUM OF BROKEN THINGS

A legless Kwan Yin statue pokes her head up from a geranium pot, her torso stump embedded in the soil. She sits just outside the gate, inviting people in. A green ceramic frog joins her, occasionally called upon to help hold the gate open.

These garden denizens are joined by statues of varying degrees of whimsy and disrepair — a concrete Tiki god (missing his scepter), another Kwan Yin with a missing ear hides beneath the jade tree, a snake head juts out from behind a spiny cactus (looking not the least bit threatening), a one-winged duck, and a slanting Buddha, who requires a couple of bricks on

either side to prop him upright. Even with the bricks, his meditation pose looks suspiciously like a drunken stupor.

The strange assortment of statuary, along with dozens of plant varieties, came to my garden by way of people who passed through: house sitters, tenants, neighbors, friends, each one bearing a story, a small fragment of memory, scattered pieces of my life.

On my fortieth birthday, the plum tree arrived in a one-gallon can, a gift from an artist friend who loves to paint pictures of trees. And the apricot was a sucker from my sister's tree 500 miles to the south. I snuck it on the airplane inside my carry-on and managed to root it. It managed to grow. We eat black figs from the tree my husband brought home back when it was a small cutting. Someone at work handed it to him, said plant it, they're easy to grow. The olive tree was a gift from the Realtor who sold us the property way back when, and it looks that old.

The bougainvillea came by way of the tenants who enjoyed the garden during the years I lived in the country. Also the brutal cactus, planted next to the entryway so a late-night visitor might get stabbed reaching for the gate latch. I moved the cactus but still am grateful to them for putting the bougainvillea in a spot I never thought it would grow.

A tiny scentless rose was a goodbye gift from a tenant who moved to the East Coast. Another deep-red rose came from a friend who no longer speaks to me though her gift blooms strong, undaunted by the thorns that ripped through our friendship. A wisteria was planted in the front-house garden by an enthusiastic tenant who did not know it could strangle the telephone wires and dig into the roof rafters. As I wrestle with the wisteria year after year, I think of that gentle woman who loved to garden, hoping she has found one of her own.

I am not an azalea kind of person — I think of them as being too needy (acid soil, just the right amount of dappled light.) Over the years I received three different azaleas — from my sister, from a colleague, and a friend. They

came in three complementary colors from white to deep rose (as though the donors had conferred), and to look at them, blooming in unison underneath the shade of the nandina bush, one would think I like azaleas.

During the years I'd rather forget, I dated a junk collector. In the brief space of our irresponsible tryst, I gained a birdbath (large enough to satisfy a pterodactyl), a ceramic Tiki god, and a driftwood chair held together by nautical ropes (it weighs a ton) that he dragged from the beach into his flatbed truck and deposited in the garden, his form of an act of love. The monstrous fabulous beach sculpture now sits royally underneath the plum tree, forever reminding me of a time when I was unable to distinguish between love and loneliness.

My mother was never much of a gift-giver. Half-gifts, I used to call them, meager and partial. For my marriage she delivered a small check and a note, telling me to apply it toward something I wanted. It was as if she knew the check, on its own, wasn't capable of doing much.

We went to Mexico on our honeymoon, and her gift managed to cover the entire amount

of a midsized clay pot purchased from a street vendor. I wrapped it carefully in newspapers and socks, but still I stumbled on the airport curb, and the pot broke in half.

I cried and cried, but, in retrospect, it was a fitting end to my mother's paltry form of gift-giving. When we got home, I took a hammer to what was left of the halves, and set the small broken pieces in mortar across our back door step. The mosaic threshold is quite beautiful, more beautiful than its original whole, and it feels good to have transformed my mother's stinginess into something worth keeping.

I cannot walk through my garden without revisiting all my foolish love affairs, tenants who became friends and friends who were lost, and some who stayed and are forever in my life.

Every year that I have lived on this small rich space, something has become embedded here. A history written not on pages but in rusted bits of metal, ceramic wings, and all those prickly thorns.

This tree that I carried
like a baby
on the airplane from the south
where it was cut away like
a tired accessory
from its overgrown source.

A shoot, not a tree
that couldn't possibly survive
the altitude change,
the northern soil,
the long shot of survival,
piece of baby wood in winter
a long way from home.

It grew like it knew it was
always an apricot tree.
Cells from this indistinguishable stick
had somehow memorized
 pale mushy clean
 juice dripping sweet
 soft fingers licking
Like nothing you ever tasted from the store!

It took two years before we really knew,
and then, like a revelation,
sweet orange-red baubles
signaled a victory
for the coming of summer.

You can never tell
what kind of brilliance
lies in a piece of wooden stick,
lies in good intentions.

STEPPING STONES

A neighbor up the street threw a dinner party — a luau complete with roast pig, exotic root vegetables I did not recognize, and all-you-can-drink piña coladas served in hollowed-out pineapple shells.

As I strolled through his garden, guided by the gentle glow of solar-powered lights, I couldn't help but compare his over-the-top exquisite landscape with my own. On a double-deep lot like mine, my neighbor managed to arrange his massive outdoor space so that one never walked on dirt or weeds, never had to so

THE IMPERFECT GARDEN

much as push aside a fallen twig. Walkways were paved with mosaic tiles separated by a pinkish crushed rock that made soft scrunching sounds under my feet. Raised planting beds, softened by ground covers of varying colors and textures, decorated every turn. And oh the foliage — lush and tropical. Intoxicating flowers, capable of seduction.

Cupping the rum-filled pineapple shell with both hands, I walked slowly through the landscape, finding myself overwhelmed both by admiration and envy. For all I loved about my garden's wildness, I couldn't help but admit it could stand a bit of discipline.

The next morning I paced up and down the length of my property and decided some improvements were in order. I wasn't about to mortgage the house to duplicate my neighbor's fabulous landscape designs, but I could certainly improve things a bit by covering the weed-strewn walking paths with stepping stones. A start.

After counting out comfortable paces from front to back (including bends and curves), I wasted no time, went to the garden supply

center and purchased 43 15-inch square pavers, tan with pale-orange streaks. Ruggedly elegant.

My husband unloaded the pavers from the car and stacked them neatly in the driveway, promising he'd help me set them in the garden next weekend. He didn't fail to warn me (he knows me that well) not to lift any of them until he could help. "We'll do it next Sunday," he assured me, not in the least bit concerned that next Sunday was seven long days away.

What was he thinking? He knows me better than that. I couldn't let the tiles just sit there with all those perfectly usable gardening hours between now and next Sunday. I'm an impatient Aries, and the weather was gorgeous. How could he expect me to wait?

The next day, after he left for work, I started in. One paver at a time, I lifted gently, remembering to bend my knees, keep my back straight, suck in my belly — I know, I know. I slowly carried each paver through the gate, down three steps, across the patio, down two more steps, back to the rear of the property. But that was just one part of the deal. The ground needed to be leveled, earth brushed

away so the pavers could be set flat. All day I lifted, carried, moved earth, stooped, dug away, paced, lifted again, separating the pavers at regular distances, setting, resetting, measuring not with a ruler (what fun is that?) but with the ease of my natural gait.

The visual transformation was immediate. Clean surfaces replaced bumpy weed-pocked earth, and though this addition hardly brought my landscape up to the caliber of my neighbor's garden, still, it was an exciting improvement. Just one more, I kept telling myself, though I was beginning to feel a bit of a strain in my lower back, but just one more, I said again until finally, as the wind started picking up and I realized

that I hadn't sat down, or drunk water, or peed, or eaten a thing all day, I finally finished. A huge job, well done. I was proud.

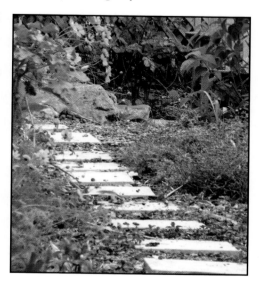

I woke up the next morning, eager to admire my previous day's labor in the new light. I couldn't wait to show my husband.

But nothing.

Only my head lifted slightly from the pillow. The rest of me was incapable of movement.

I've heard people talk about their backs going out. Funny expression. As though the back were capable of making its own plans, distinct from the individual.

Aha. So this is what they were talking about.

After my husband gently rolled me off the bed, then lifted me like a manikin to standing position, I shuffled to the living room, where I spent the better half of the next week, flat-out on the floor. Five days of round-the-clock anti-inflammatories and ice packs eventually brought me relief. By the second week I was able to get around pretty well on my own. Very, very slowly.

OK, OK, I know it. I was stupid. I had no business laying heavy tiles by myself. I could have waited, should have waited, could have, should have, a monotonous mantra that bored me silly

while the hours and days wiled themselves away and my bruised back started to heal.

Mercifully, my husband spared me "I told you so." Nor did he comment on the beautiful tile stepping stones outside the window. A fair trade-off I suppose.

So there it is. The harsh truth, harsher than the difference between my neighbor's masterpiece and my erratically original work-in-progress. I can no longer do all the things I used to do in my garden by myself. I can no longer move a large ceramic dirt-filled pot from one end of the deck to another or transplant the cape honeysuckle on a whim. Even though I may feel like a kid in a sandbox when I'm working in my garden, my bones and muscles are not so easily fooled. So I must learn to be prudent. I must learn to be careful. I must learn to be patient. Even though I'm not.

REGRETS

Some days I am paralyzed by regrets. I judge myself for whatever I think I should have done or should not have done, if I had only known the difference. On those days I take myself out to the garden.

Whatever the time of year, a thick lush waste of last season's plantings will quietly be mulching its way into the next cycle, sending out smells, some fragrant, some not. I walk slowly through

the maze of possibilities, breathing the perfume of freesia and mint, or the subtle reek of dead leaves turning.

Quick snippets of ceanothus, pittosporum — just about anything woody and tired — can be snapped clean. Or I may pass by the drooping abutilon, decide to prop it up or else just leave it to sling down over the iris leaves, something I will later regret. There may be nothing to do other than rake broken twigs and wet leaf clumps, and even this will do me good.

Once I start, the work itself propels me. I notice the ixia and hyacinth pushing up or a mound of sweet-pea sprouts poking through a blanket of dried leaves. The ground around them needs to be cleared to give the blooms some room to show off. Rooting for a rake inside the tool shed, I run into the bag of fava beans tucked away, waiting for this very day to be planted. I notice a few volunteers from last year's dead tomatoes and transplant them to a more suitable spot, knowing full well their season is past. If only I had staggered the plantings every other week through June as the books suggest, I'd be eating tomatoes still. Regrets again.

The easy work beckons: a quick turn of the compost bin, untwisting a kinked hose. The old nierembergia has outgrown its pot. In its place I stick the leaf of an always-easy, never-failing succulent. I slide my hand across the peppermint patch and let the smell fill me. I sit on the brick step, inhale the sticky-sweet narcissus. Notice how quiet my mind has become, how calm.

Energized, I move on. It's high time I transplant the heuchera to an airier home. How long have I been telling myself to do that one thing? Wherever I step, more acacia and honey bush shoots. I rip them out before they give me more reason for regret. Again I notice the ever-blooming impatiens, its thick wall of coral pinwheels whirring bright in the wind. I barely appreciate them. "It's just the impatiens," I think, because it is so easy to overlook the gift of constancy.

Everywhere I turn there is something to do. Leaves collect along with the carcasses of last year's annuals. Space continually opens up between plants, reminding me to fill in more bulbs, move the delphinium to the spot where the zauschneria failed. If I never did get around

to planting sweet peas along the fence, now is the time I'll regret it. If only one small clunk of zinnias actually grew from the seed packets I scattered, now is the time I'll wish I'd bought the six-packs instead.

The light is constantly changing. Even as more tasks present themselves, I want to be

still, smell the air, watch the colors and shapes change before my eyes.

The basil did well. Three varieties this year: Italian, African and Thai. No regrets there. I take deep, long sniffs. And despite the neglect, the cucumbers have kept producing months past their time. Go figure. The steadfast lavender, penstemon, and potato vine continue to flourish. And the constant, hardy chard that provides year-round lush stalks of yellow, red, and green leaves, always ready to eat.

I must remember to appreciate the plants that thrive, whether it was a year I worked hard out here or did nothing at all. I must remember to appreciate more and regret less.

Minutes later, or maybe hours, I begin to notice my muscles are sore. I slump down on a brick step or smack in the middle of a planting bed to catch my breath. From that vantage point I see that the rose campion has overtaken its pot and the gladiolas have out-distanced their stakes. I try to get up, but the shovel is blocking my knee, my shoes are caked with mud, and a rose thorn juts dangerously close to my elbow. Besides, I'm too exhausted to move.

But I'm not ready to stop. Not quite yet. Not as long as the light lasts.

This is what I did today:

moved rocks;
fluffed edges of dried leaves
to keep pots damp;
coiled hoses round;
cradled tender slips of sweet peas;
moved the jade from a dark, forgotten
corner;
waited for the beans to sprout;
untangled the climbing vine
that will soon sprout brilliant pink,
and tacked it to perfection
on a dull and waiting wall;
decided to transplant the lettuce;
decided not to transplant the basil,
knowing full well they do what they do.
and after hours of this constant
movement
carrying, training, trailing, deciding,
I sit satisfied and smiling,
like the ruler of a kingdom.

And even in this state of smugness,
there are the snails
to consider.

THINGS I GOT RIGHT

It has been at least two months since I stepped outside. A new job, a touch of the flu, the holidays, not to mention two grandchildren in six months. It happens that way — the garden waits while life presents itself in other interesting forms.

But one bright January afternoon that interrupts weeks of icy rains, I finally step through the sludge and slosh of last year's leaves. Not time yet to attempt any useful activity. Just pick up a wayward branch here and there, squish a couple of snails. The birds lined along the fence take turns at the feeder that has become a highway of activity. Not too long ago, the birdfeeder was empty of wildlife, and I waited impatiently, thinking the birds would

never come. But they did come, in great loud squadrons. And now I know there is enough to feed the birds and the squirrels. There is enough for everyone.

In the fresh clean of winter, I circle the perimeter of the inconsistent garden that has become my mirror. Last spring I planted an elaborate vegetable patch — bok choi, broccoli, five kinds of lettuce. It was late in the season, and the nurseryman wouldn't even charge me for the pathetic six-pack of broccoli left on the counter. He said, "Take it, good luck, maybe you can get it to grow."

And it grew despite my neglect; despite the cutworms. Six broken broccoli starts produced a thick collection of healthy heads. I watched them from the kitchen window and thought to pick them, but there was always a distraction, a misplaced priority. It amused me just to see them there, challenging me.

But it is too late now, the shriveled finished flowers no longer fit for eating. The cutworms feast away, and I think this is how I have lived much of my life: preparing, planting, nurturing, but forgetting to harvest.

I have now lived here going on thirty years. The marriage that brought me here is so long over I barely recall a single detail, other than the noise of hammers and skill saws, the ever-present sheetrock dust. My new marriage is no longer new but deeply rooted, and through it all, the bamboo continues to drop fronds all over the pathways, and the bricks continue to slip and fall and form new pathways. Every new plant and every old plant continues to reposition itself for the coming season. There have been miracles here, the garden itself a miracle, having survived a fire and years of intermittent neglect. The abutilon and impatiens that bloom their way through the grey gnarl of winter are miracles. Also the bulbs that keep returning.

And still I judge myself for the empty spaces where I scattered seed too thinly. Even after all this time, I'm never sure what I want to plant next or where to plant it, and still I notice that everything continues to bloom into a rich loam of years. The old medicinal herb garden is all but gone, save for a few patches of artemesia, tansy and comfrey that are relegated to the back perimeter. A native redbud now graces

that section of garden, the ground covered by mounds of acacia mulch, forestlike in its simplicity. This ever-changing landscape continues to be a place of second chances, a place of forgiveness.

And lately it has been reminding me that I am growing old. That sprite of weed that turned into an acacia tree now shadows the entire back of the property. The plum tree planted on my fortieth birthday is looking a little haggard, its plum production having peaked a few years ago. It has been patched more than once, scarred by black tar that once saved a fallen branch, and still survives the damned ants that keep climbing up its trunk. I will likely outlive my plum tree and have already outlived the apricot.

While the years have drawn inexorable sags and droops on my face and form, my garden has grown all the more shapely and beautiful with time. I've been its greatest critic throughout the years, forgetting that for the first decade or so, it was nothing more than a trash heap. Back in those days, I used to throw carrot seeds in and around the layers of roofing paper just to see what they would do. I still remember how the nasturtium bloomed rapturous orange blasts up

through the piles of broken glass and sheetrock dust. I look around and notice that I have finally managed to vanquish the blackberries and the comfrey, despite their wild audacity. The crabgrass has finally ceded to the calendulas, and it's been a while since I recall seeing honey bush shoots in the walkway.

And I have to admit, parts of this landscape look like something out of a gardening magazine, glossy and perfect. The tibouchina revived after near-death several winter storms ago. After being cut almost to its core, it has grown once again into perfect form, draping soft purple pedals on the ground. And beneath it, the ice plant encircles the bed in a gaudy red haze, softened here and there by narcissus in winter, stargazers in spring. The morning glory has danced its way across the front perimeter, over the trellis and through the bamboo. The wall of hollyhock, thickened over time; the marriage of daylilies and mums; the purple and red weave of penstemon and morning glory; centerfolds all.

Still the lemon balm comes up everywhere. Still the wild onion.

My sons, for whom the garden was never

more than an awkward and unsteady playing field, have gone off to start their own homes and gardens. They call me with questions: "Do I need to stake the bougainvillea?" "Do I know of a tree that can hide the neighbors?" I visit them with trowel in hand, bringing cuttings from my garden, succulents, geranium, anything that can survive a day in a suitcase. The cuttings transplant easily into their sunny soil. My toddler granddaughter loves to dig up worms. With wobbly legs she orders me, "Outside, gramma," and so we march, shoeless, into the muddy regions of her backyard where only gardeners go. This is how I know I've done some things right.

I will always battle the oxalis, always wonder if I'll ever be rid of it. Of course I know I won't. Not as long as my hands and knees and heart sustain. The constantly changing stubbornness of every mistake I ever made in this garden continues to unearth yet more surprises. Like a fascinating lover, like a clever traitor, like a stubborn old friend.

AUTHOR'S NOTE

I had been collecting garden poetry and essays for years and was thinking about writing a garden memoir. But the writing had stalled, and I knew the book would not be complete without illustration.

Rachel Michaelsen, who lives in my neighborhood, came to one of the plant and seed exchange gatherings I hosted for a community garden club. People milled around my garden, inspecting each other's plant specimens, asking genus and species questions, and sharing the bravado and disappointment inherent in all gardening stories. They were all eager to go home and plant their new acquisitions, relieved to have unloaded some of their own overgrown plantings.

Rachel did not bring any plants, but she did have a camera slung over her shoulder. I noticed her stooping beside the ceanothus, wriggling behind the morning glory, snapping pictures.

At the snack table (a delectable harvest of neighborhood bounty: sun-gold tomatoes, lemon cukes, fresh eggs, figs, home-cured olives), I overheard her telling someone "I probably have taken over a thousand photographs of plants."

It didn't take us long to exchange numbers and intentions, both of us immediately interested in the idea of collaborating on a gardening book. She wanted to start right away, but I needed time. I had only begun to flesh out the book with ideas from my garden column and with a few poems I had been collecting since I first started digging. Some chapters sat dormant for months at a time, some sparked to life instantly, still others faltered and changed shape altogether. Rachel was patient. "It will happen when it happens," she assured me. I promised I'd call her when the writing was finished. Two growing seasons later, I did.

The process of selecting her photographs to accompany my text was remarkably easy. As we scrolled through the lush field of her portfolio, the photographs and words seemed to find each other. Only once, where I refer

to daffodils as "ladies whispering secrets in the sunlight" did we come up short. Her daffodil shots didn't quite match my description. But that photograph of three bright white daisies mimicked the metaphor exactly. Careful gardening readers will probably notice the discrepancy.

The making of this book evolved as unpredictably as the garden that inspired it.

ACKNOWLEDGMENTS

The seed of this book was planted in 2001, when Toni Locke, then editor of the MacArthur Metro, asked me if I would be willing to write a monthly gardening column for the community newspaper.

The seedling was nurtured by the enthusiasm of Oakland's Laurel District gardening community, as neighbors shared plants, seeds and stories, inspiring me to give voice to my own garden's story.

Thanks to the careful eyes and ears of fellow writers Dennis, Jillian, and Laura — whose thoughtful feedback and interest helped me prune and shape the book.

Thanks to Rachel Michaelsen, for planting her beautiful photographs in between the rows.

To my editor Anne Fox, whose guidance and inspiration extends far beyond the scope of language. Thank you Anne, for reminding me that nasturtium do indeed make excellent cut flowers, and for helping me root out every last weed.

Finally, thanks to my beloved Brooks, who shares this garden with me, flowers, thorns, and all.